THIS BOOK BELONGS TO

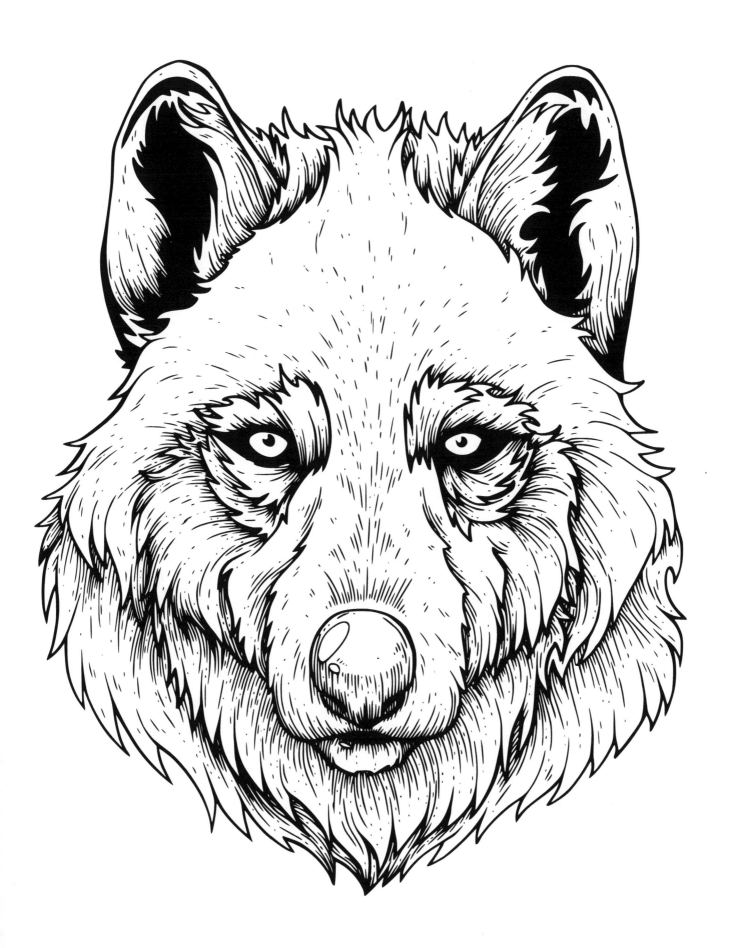

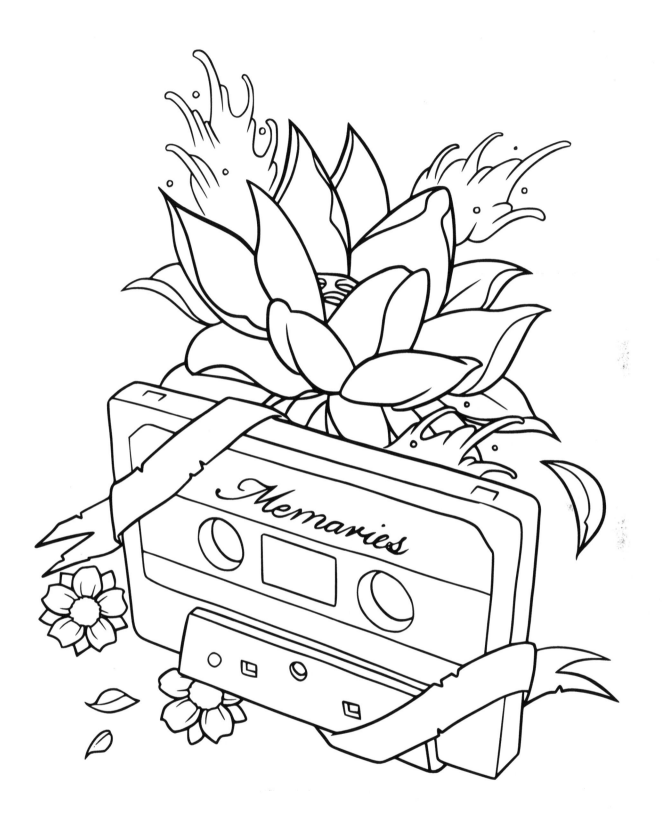

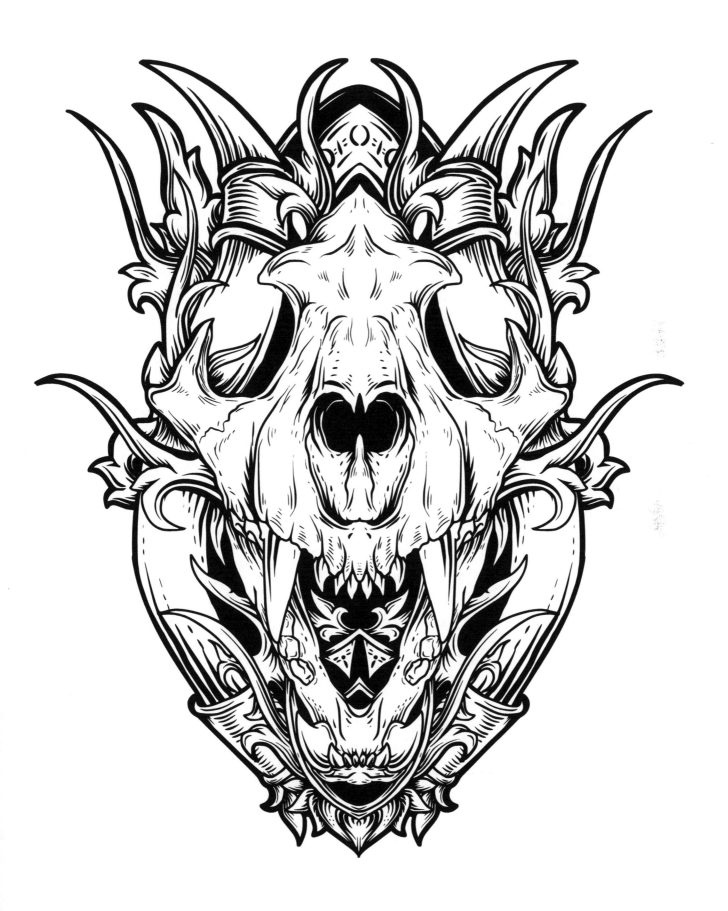

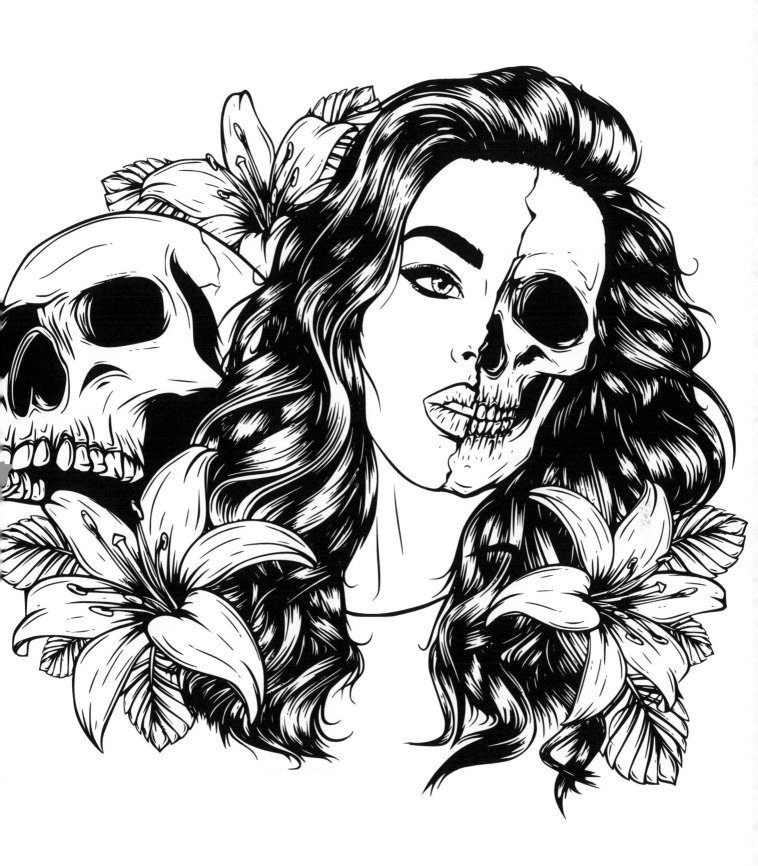

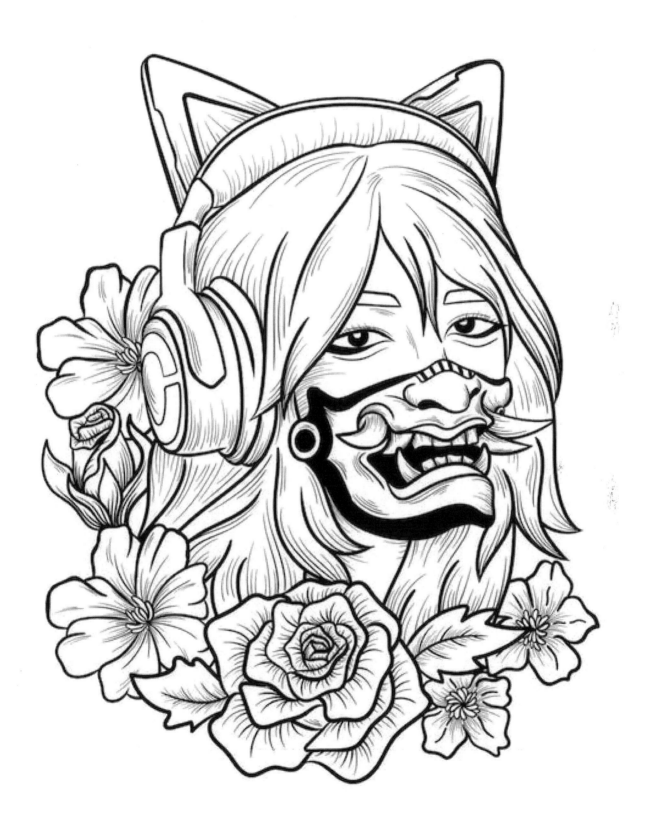

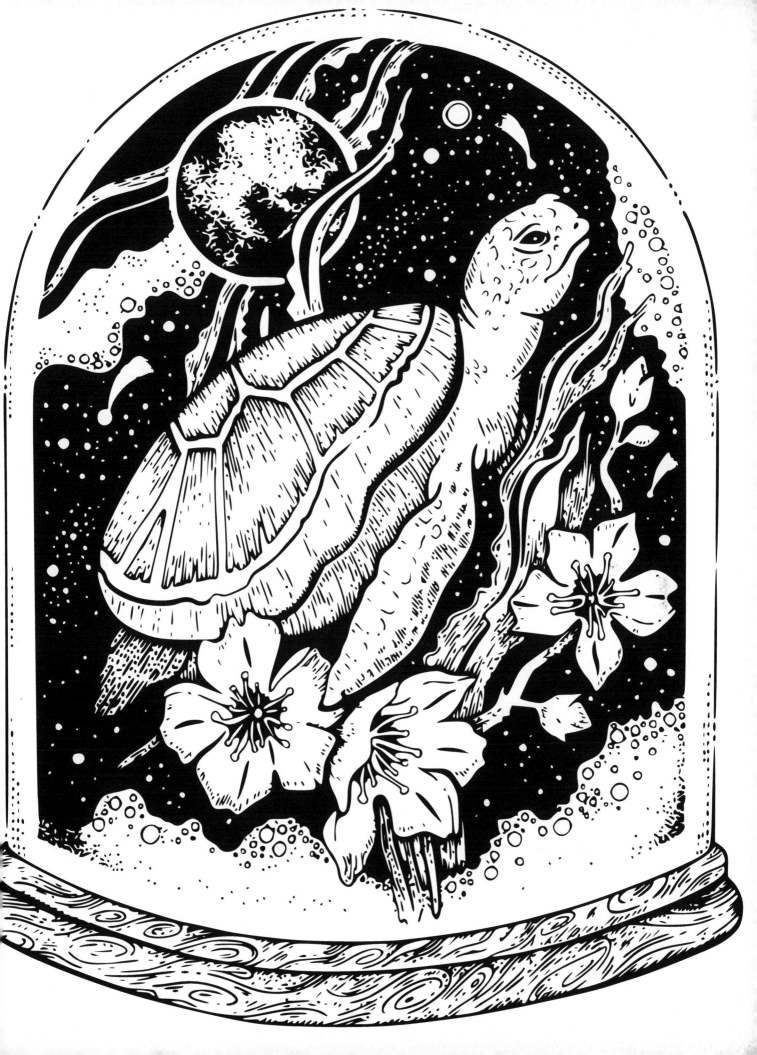

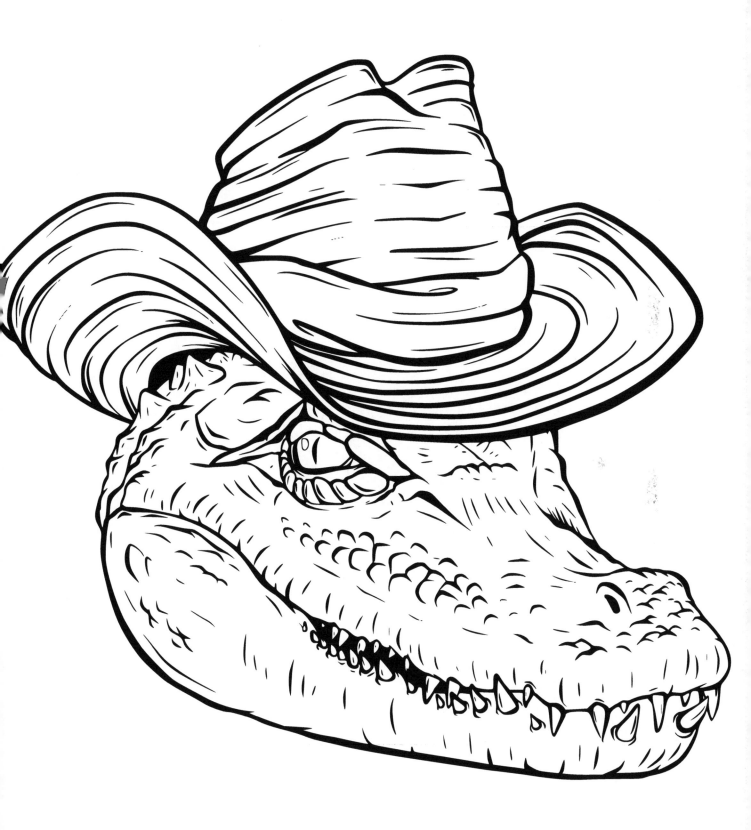

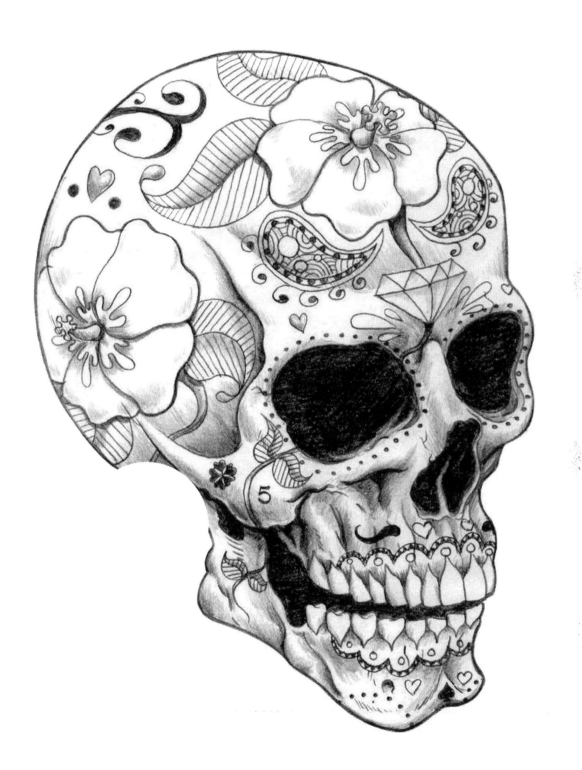

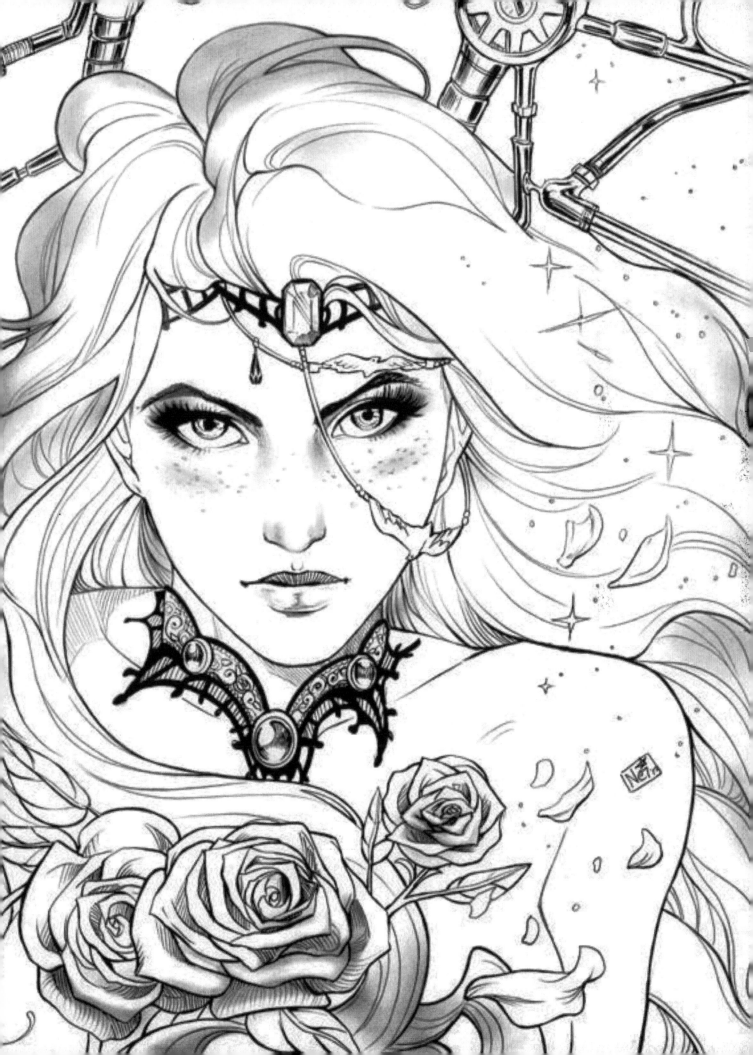

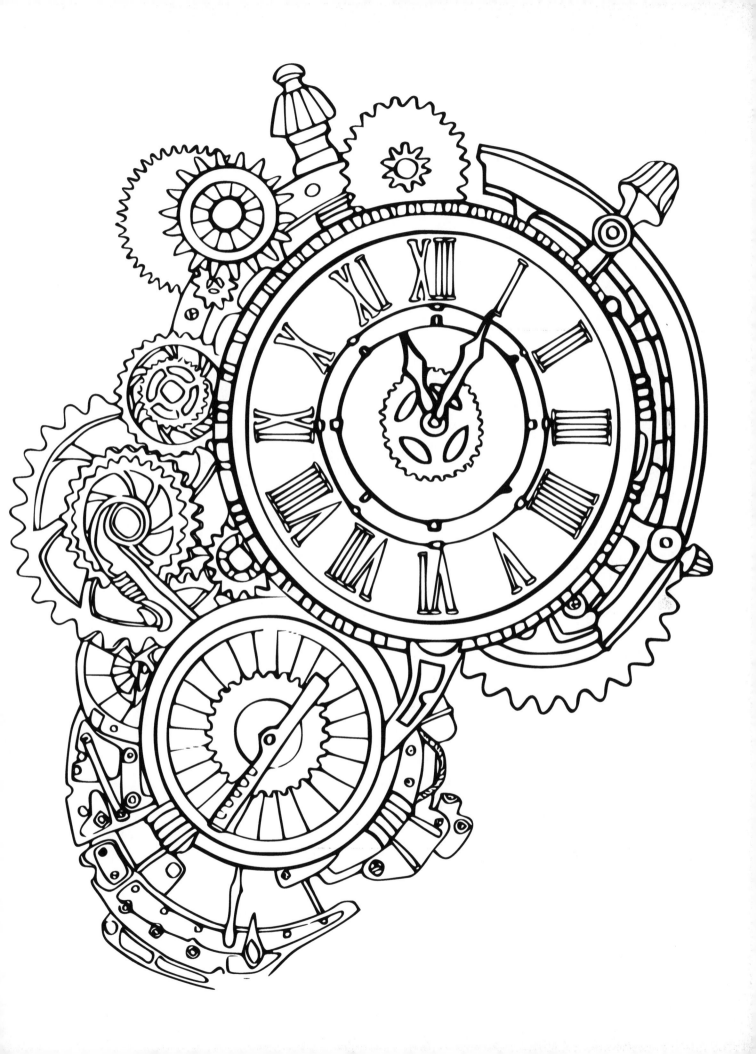

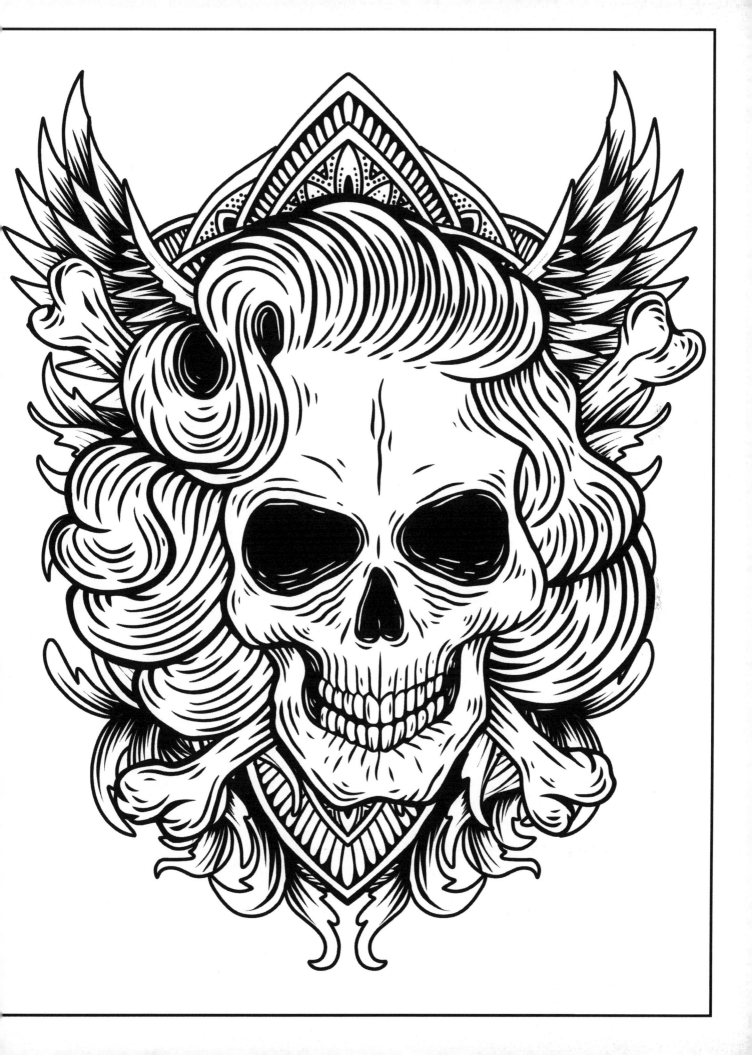

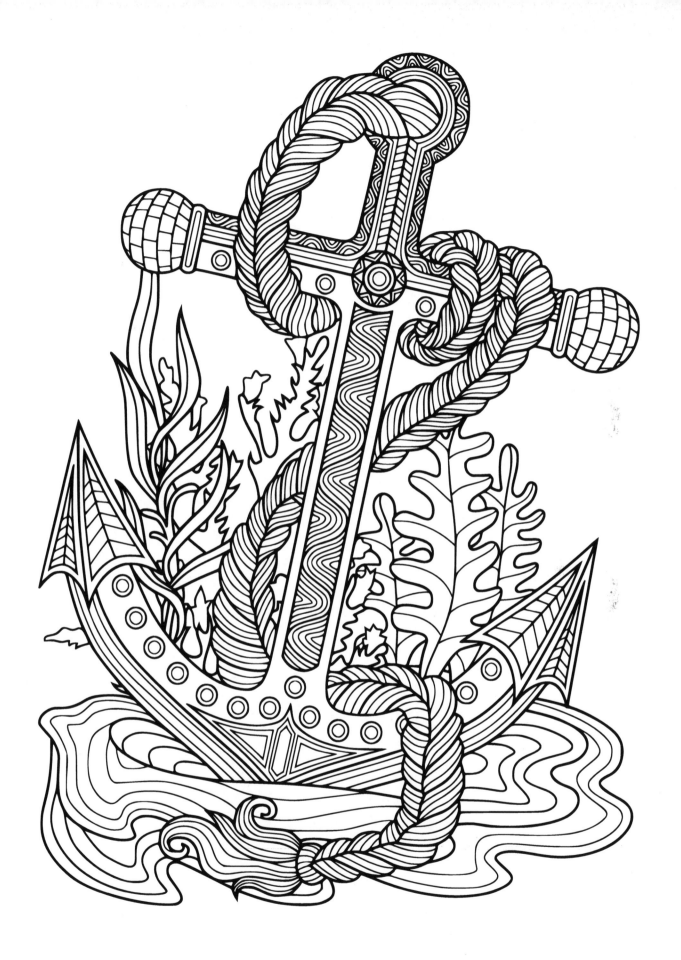

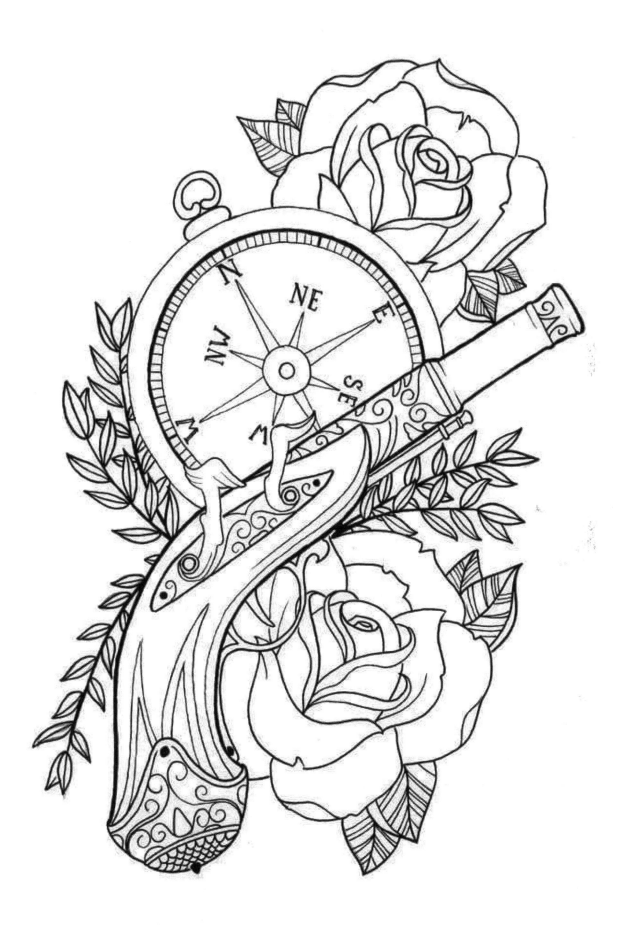

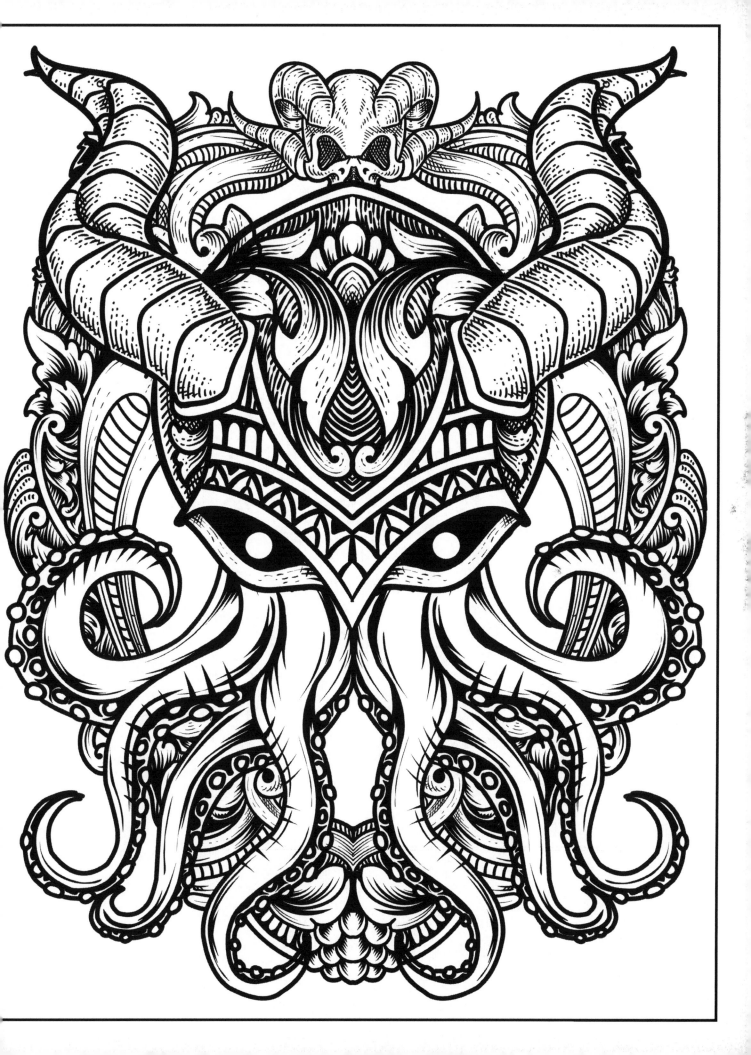

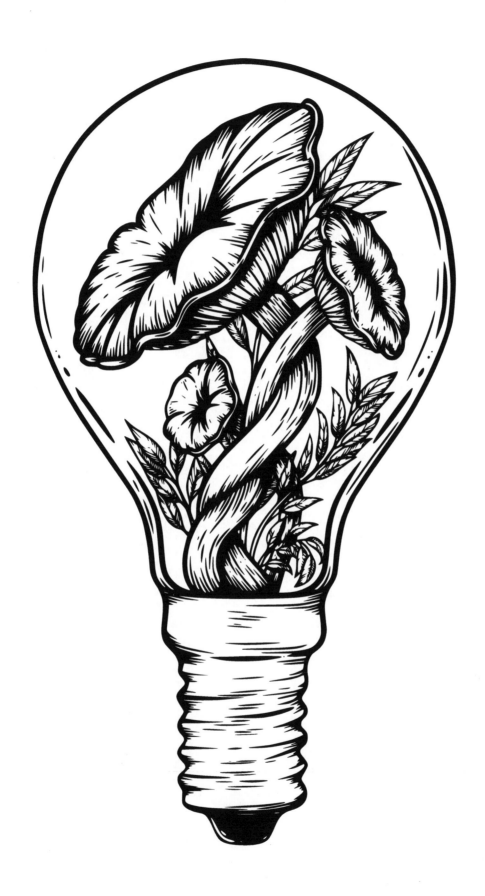

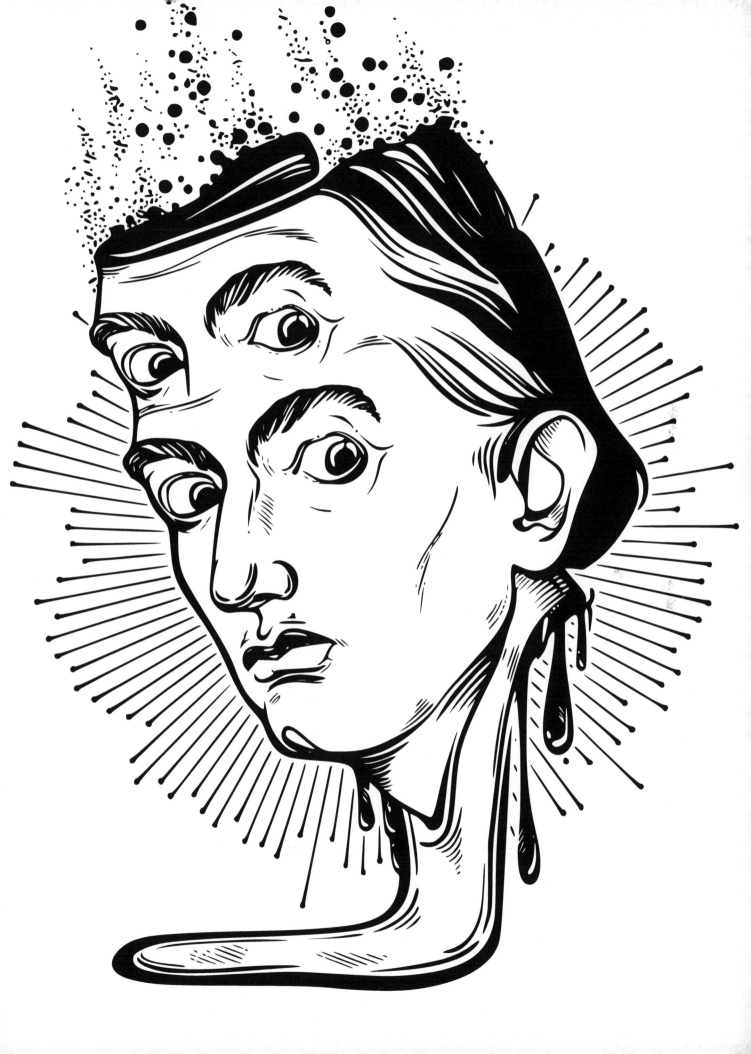

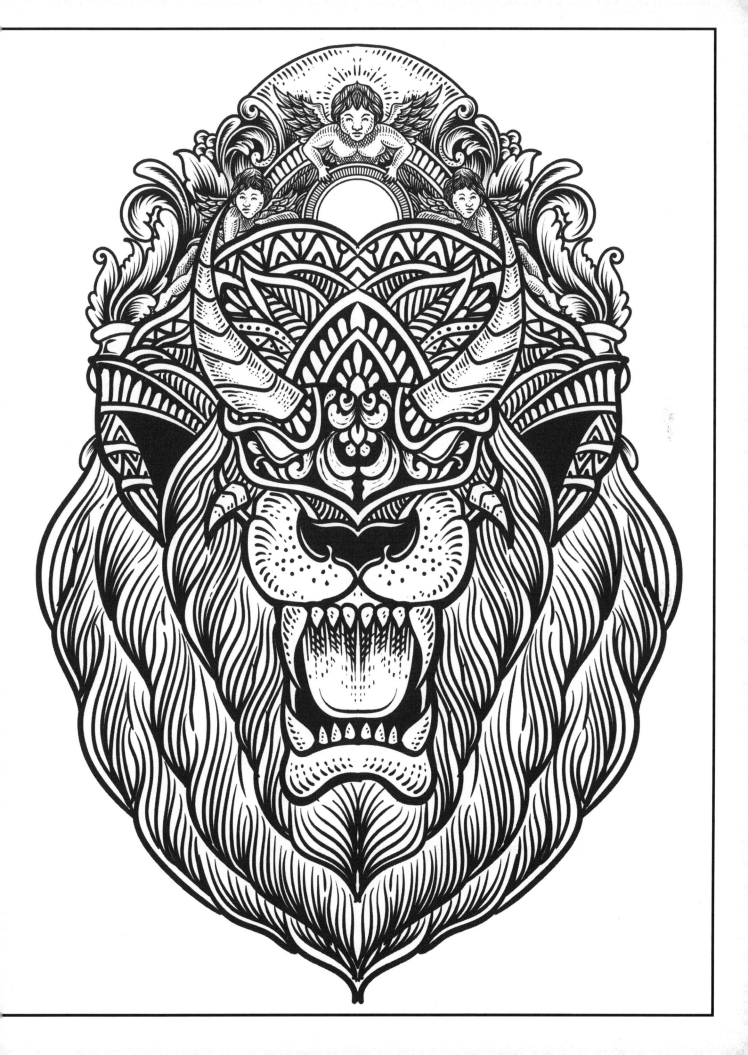

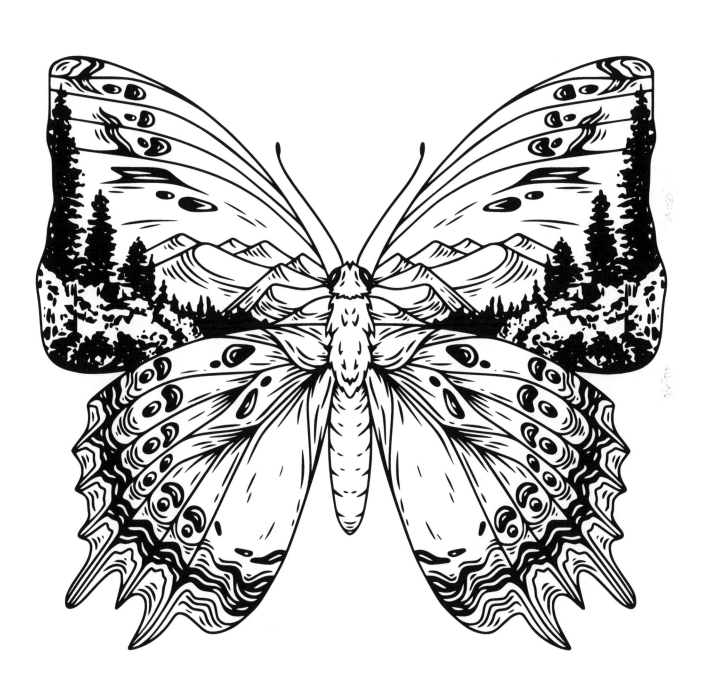

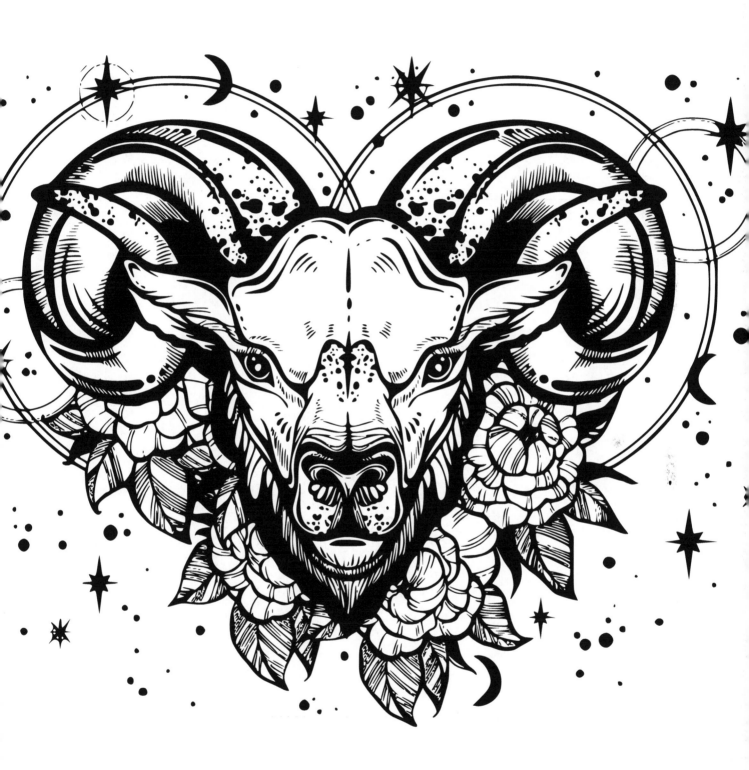

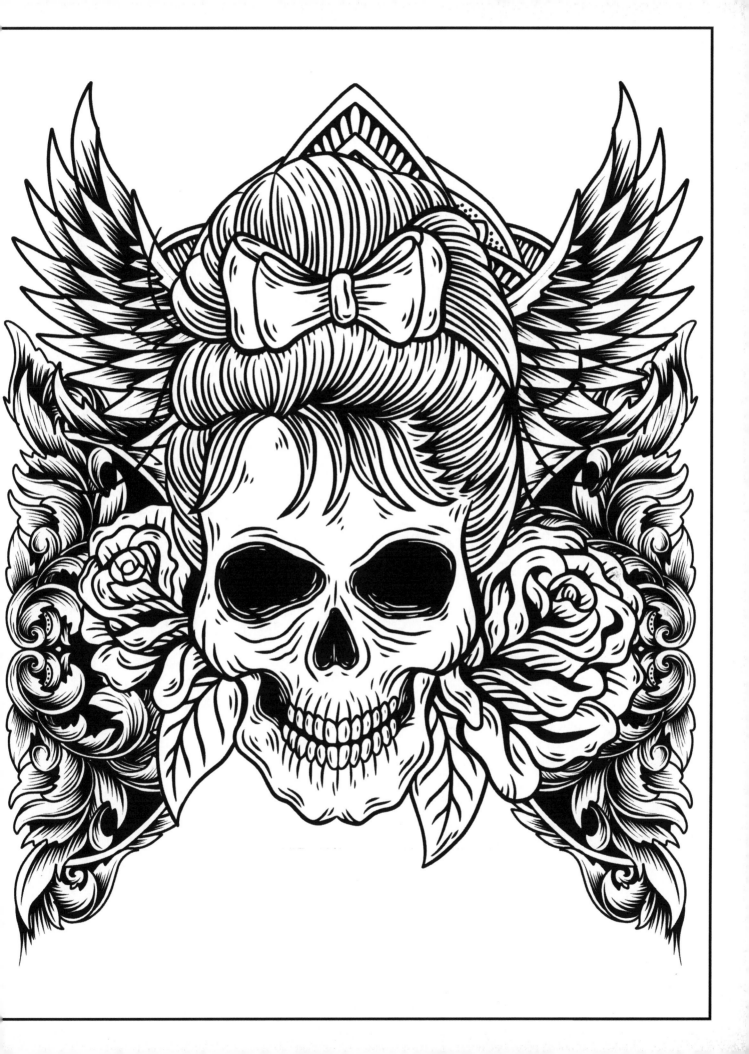

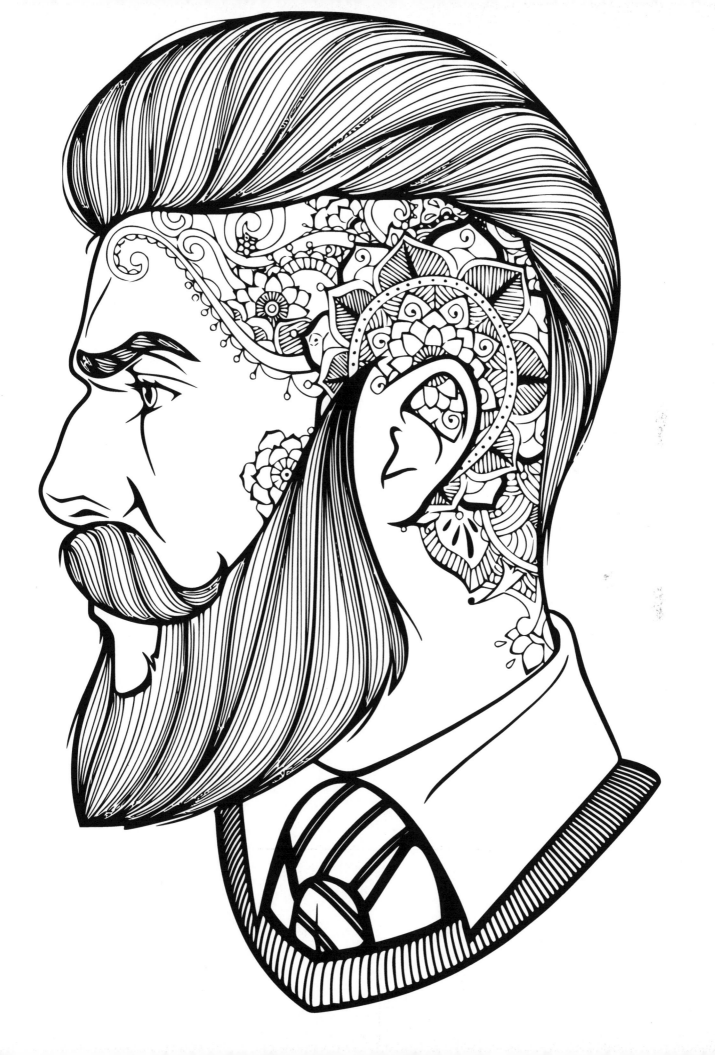

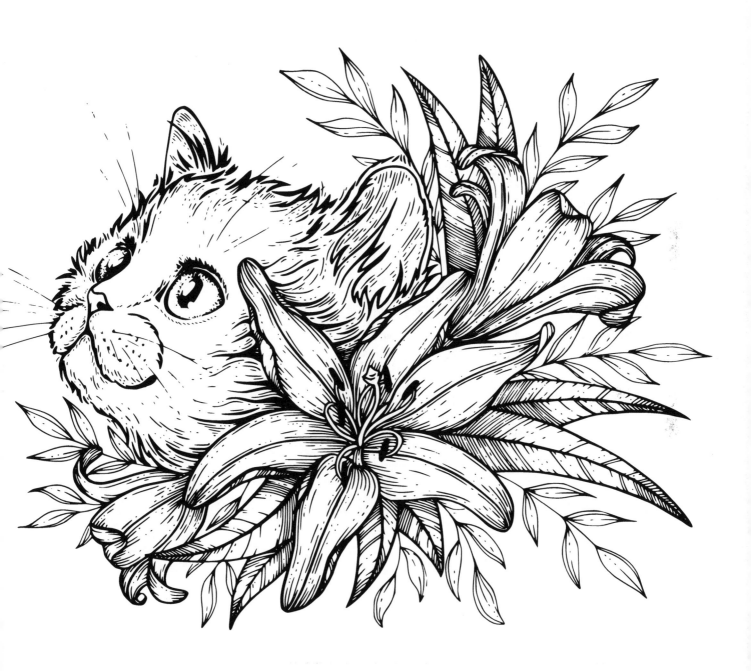

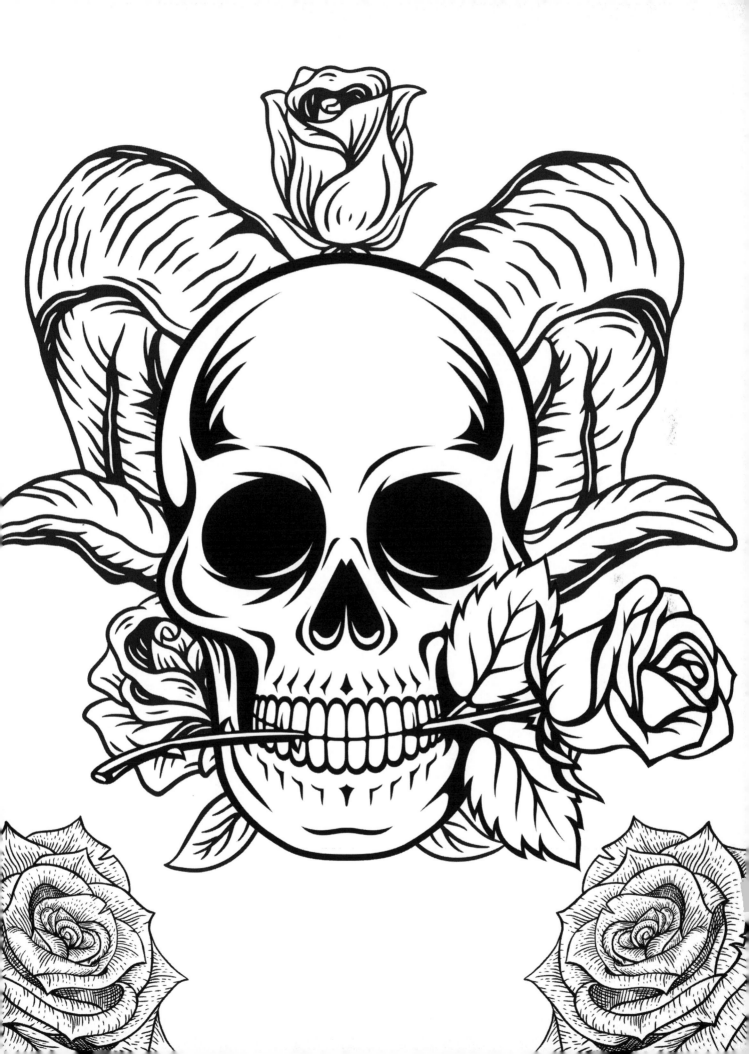

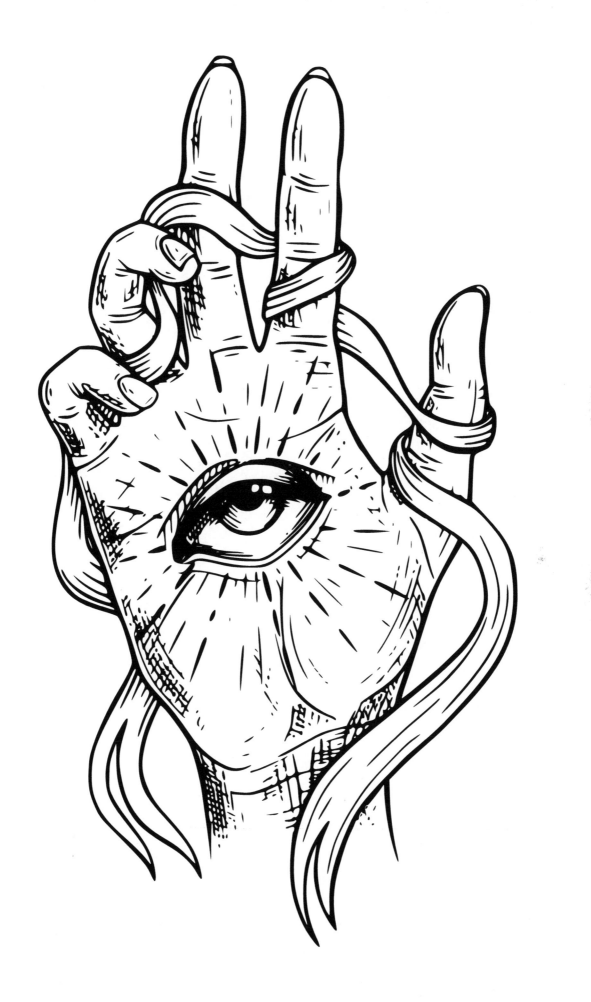

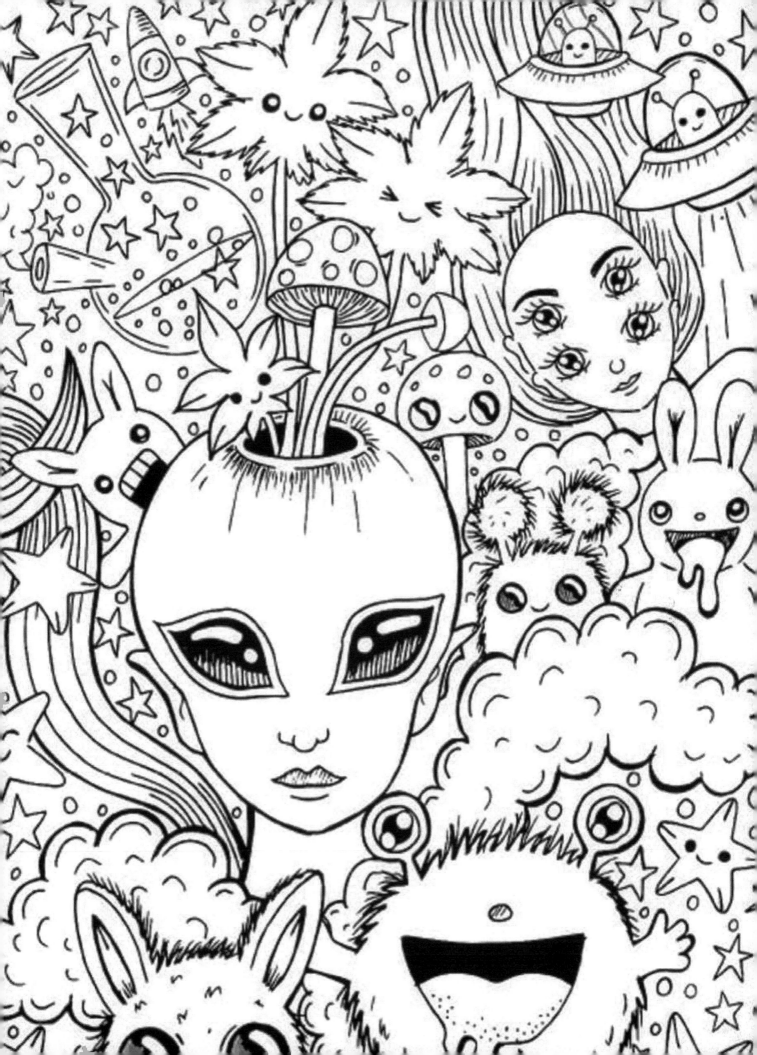

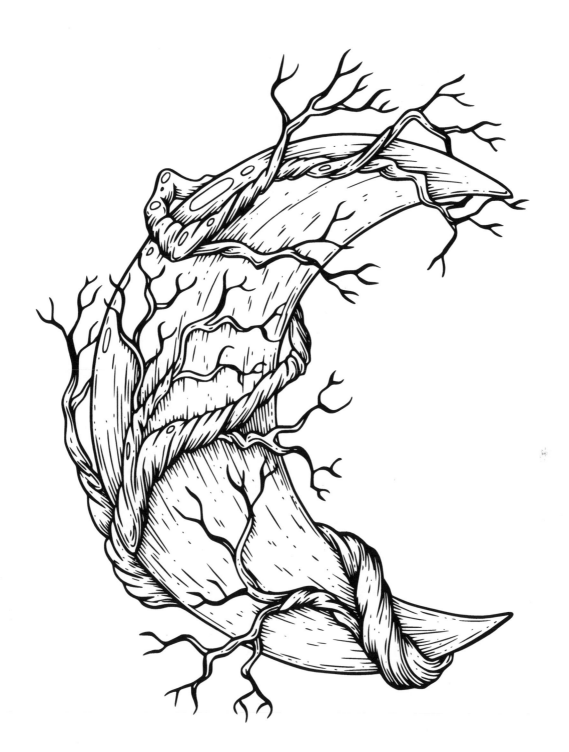

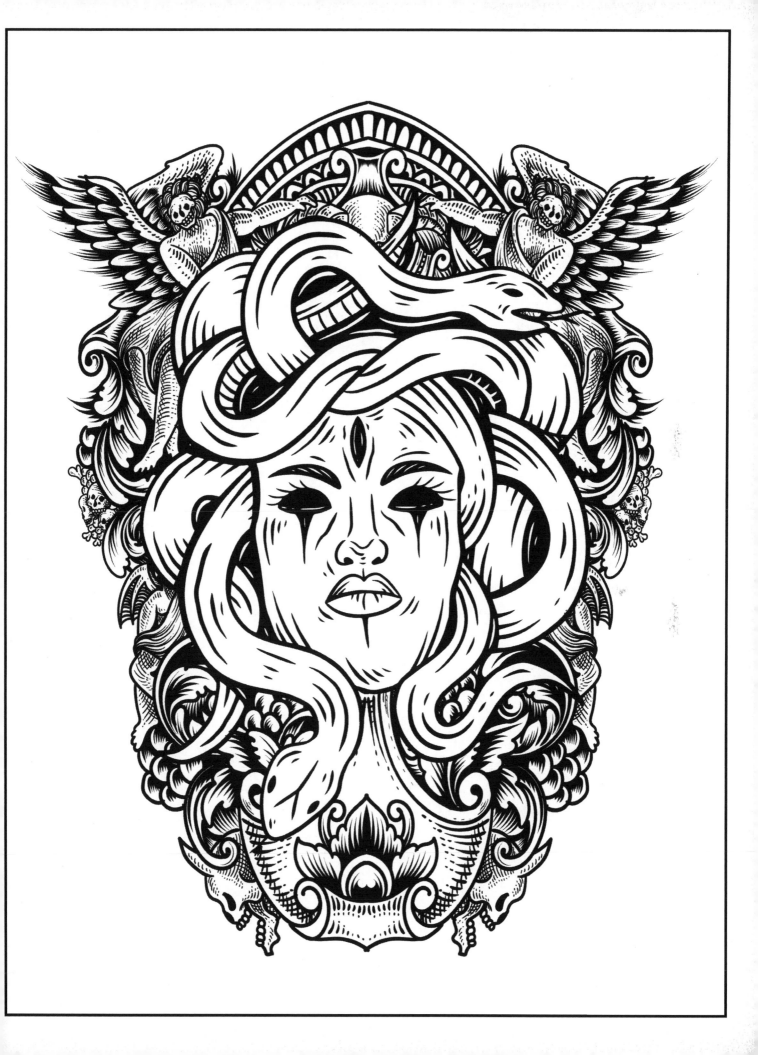

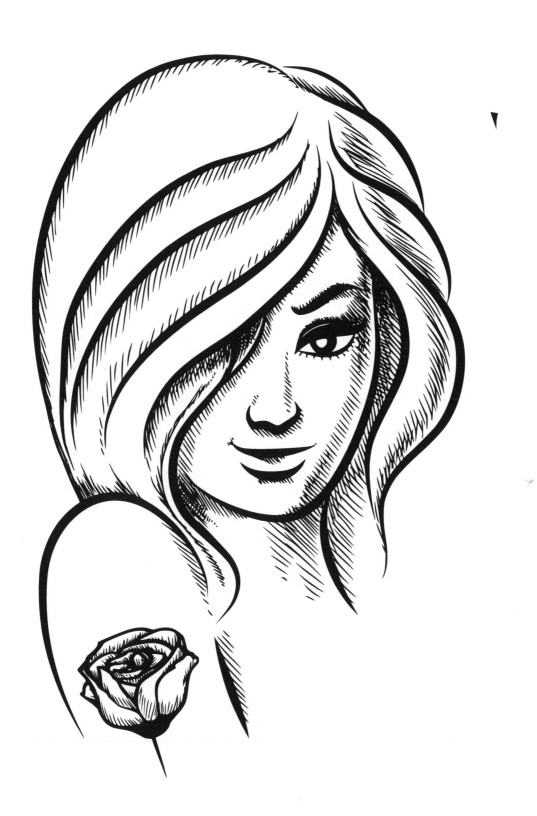

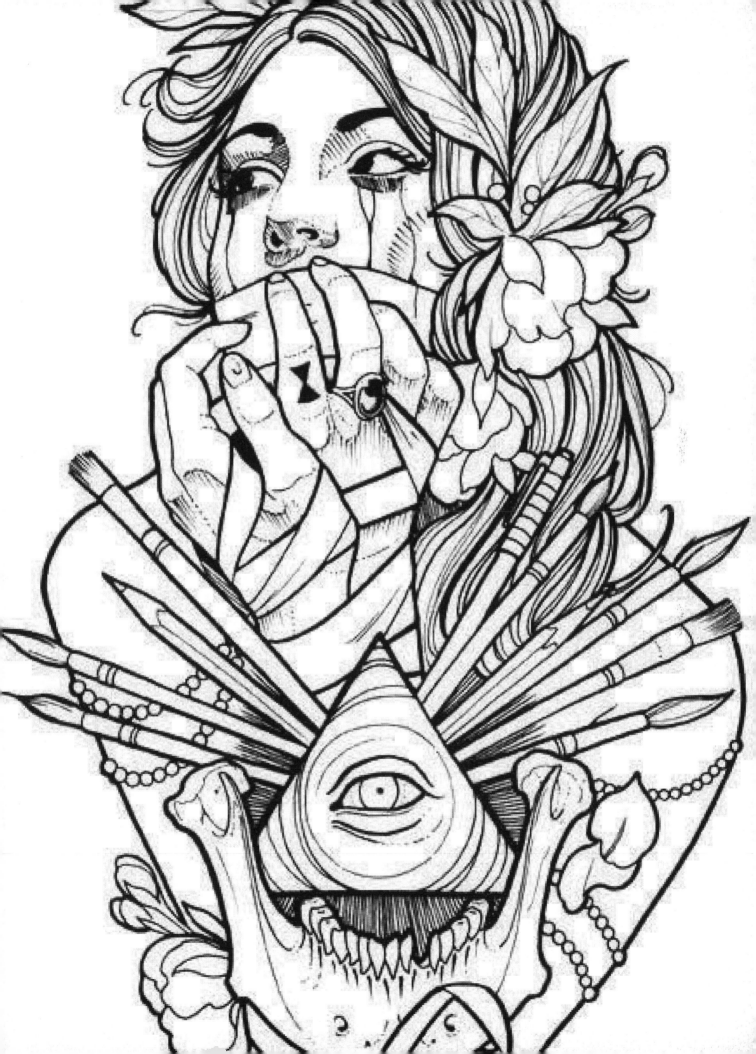

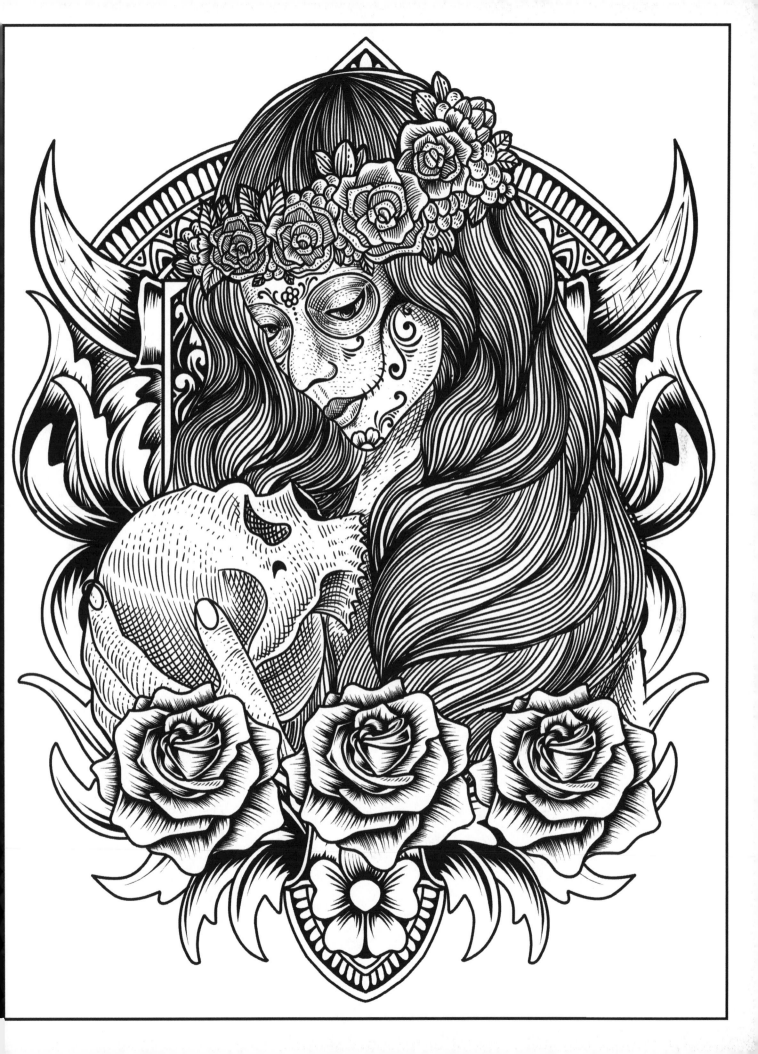

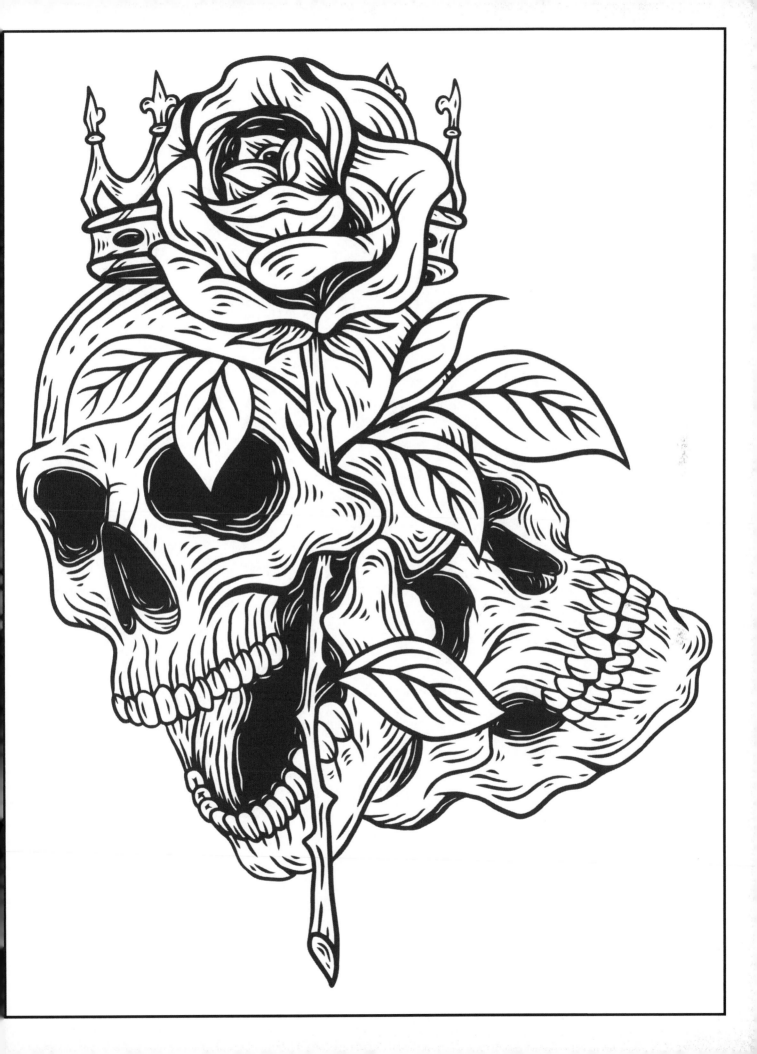

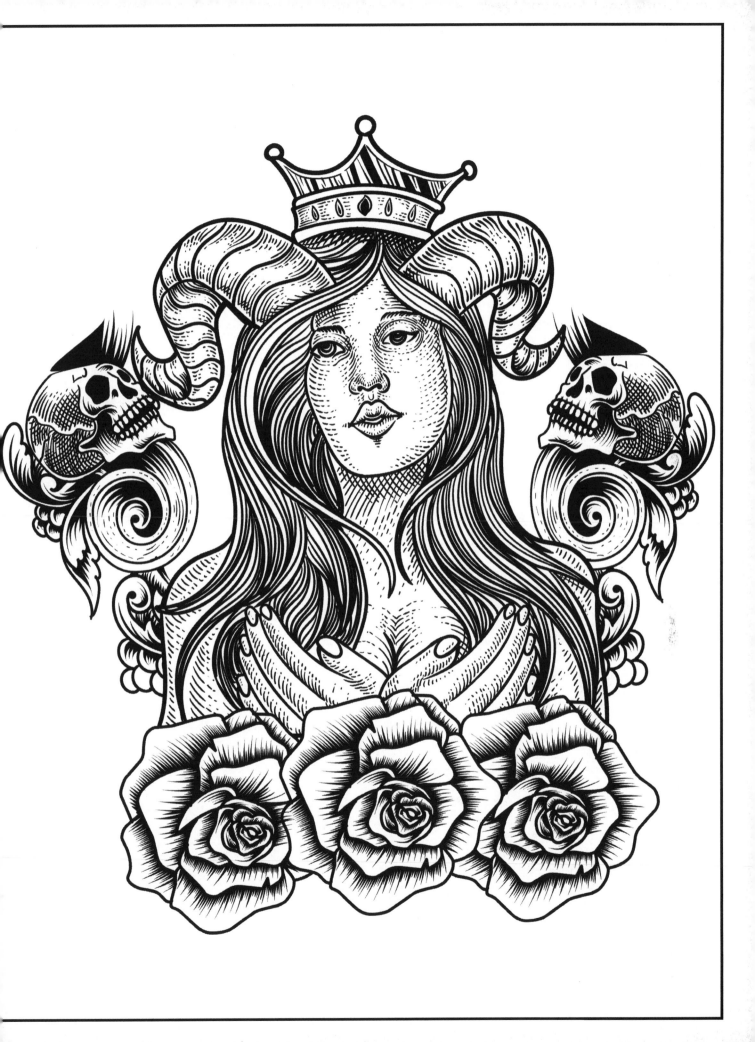

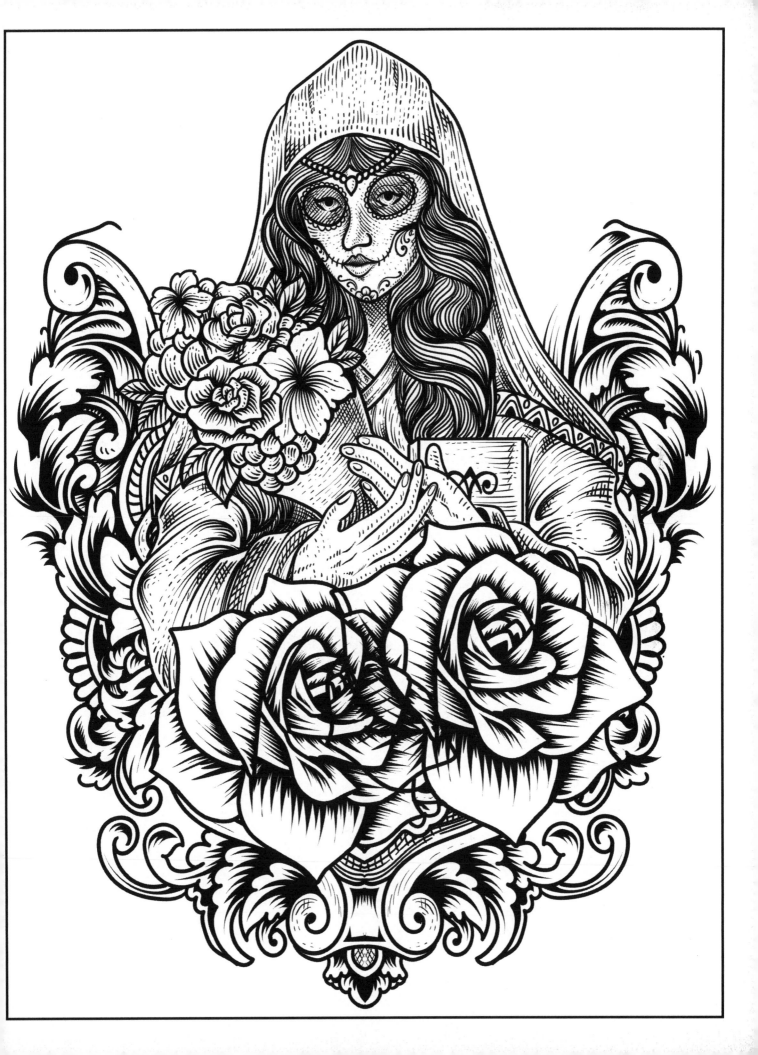

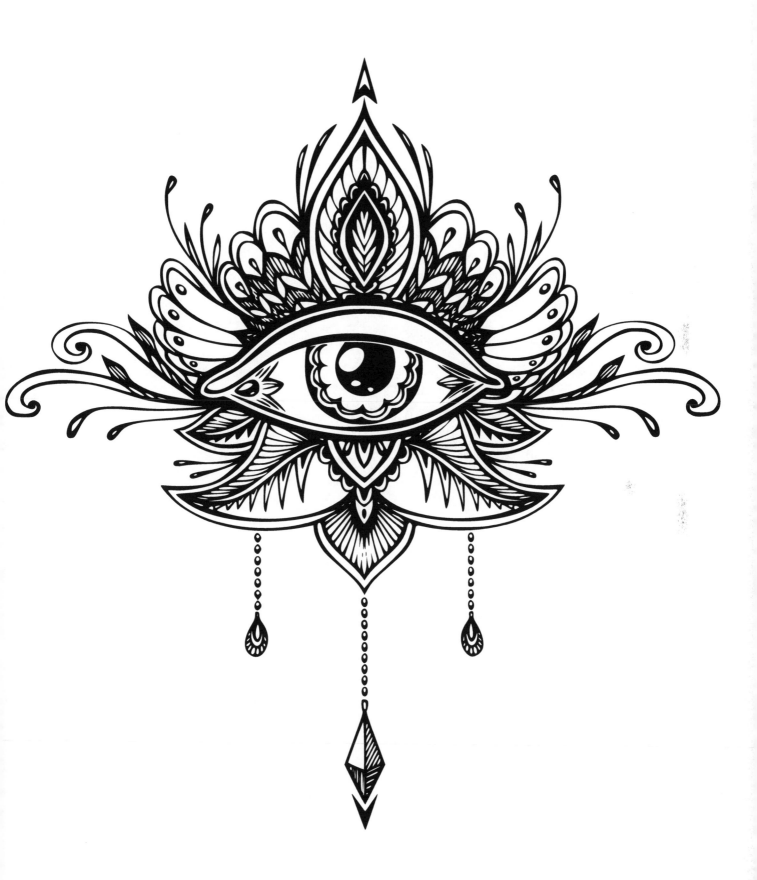

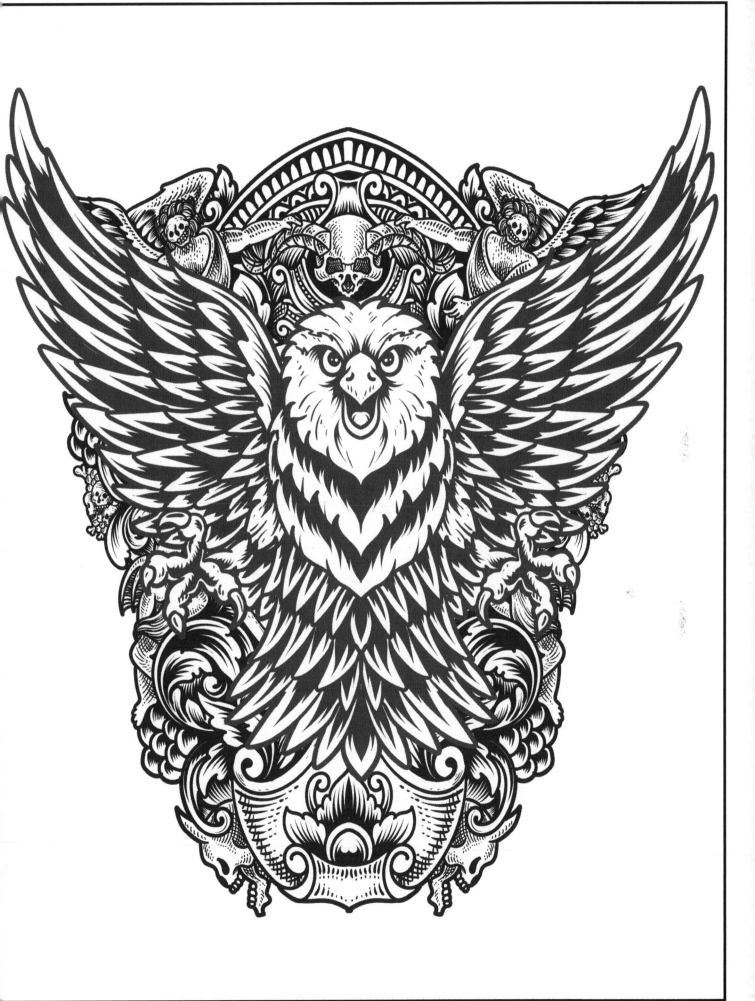

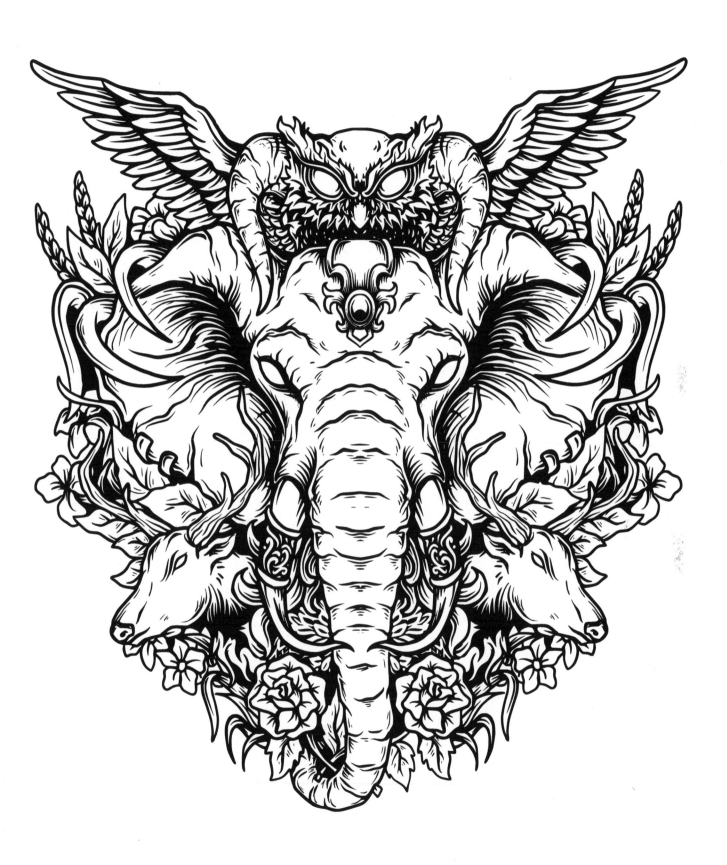

History of Tattoos

The Evolutionary Timeline

One would be forgiven for thinking that tattooing is a fairly new art form, one that's still finding it's place in society. In fact, the humble tattoo has been through a long evolution, having been performed since early times. Where did the tattoo begin, and how has the art form changed over the years? Here's a timeline of the evolution of tattooing.

Early Tattoos

The very first tattoos are thought to be from around 3370 BC to 3100 BC. This is where the earliest evidence of tattoos comes from, on the mummified skin of ancient remains. In fact, there are some cultures that are believed to be tattooing skin as early as 2100 BC

Evidence of tattooing in early culture has been seen in China, Sudan, Russia, Greenland, The Philippines, and more. It's clear that it was a widespread practice in many areas of the globe.

Some of the earliest evidence of tattooing comes from Otzi the Iceman. Otzi is a mummy that was found in the Otxal Alps, which is how he got his name. He has a total of 61 tattoos on his body, most of them found on his legs. Experts believe these tattoos were achieved using soot or fireplace ash.

Ancient Tattoo Practices

Many tattoos date back to ancient traditions, which vary from country to country. It's fascinating to see how these tattoos have changed over time.

China And Asia

Here, tattoos were believed to be barbaric, and so having tattoos was a stigmatised practice. Despite this, tattoos have been found on mummies in Asia dating back to 2100 BC to 550 BC.

It is believed that as punishment for criminal acts, criminals would be branded with a tattoo on their face. This was to warn others that they were an unsavoury character that could not be trusted. Ancient Chinese literature refers to bandits and folk heroes having tattoos.

Samoa

The term 'tattooing' may have come from the Samoan word 'tatau'. For tattoo. In the Samoan culture, tattooing is a cultural practice, a skill handed down from father to son. The act of tattooing has been passed down for over two thousand years, and is usually done by hand. In fact, the way tattoos were done was very painful and often lasted for weeks at a time.

The tattooing tools was made from boar and shark's teeth. There were often ceremonies where a new chief was tattooed to mark their ascension to the role. If someone were unable to bear the pain of the process though, they would bear the brand of shame

Egypt

In ancient Egypt, experts are of the opinion that tattooing was only done as a procedure on women. This is thanks to the little evidence of ancient Egyptian male bodies with tattoos. On the other hand, the mummified remains of women were often found with tattoos.

What's interesting is that the act of tattooing may have gone through development as a medical practice. Examination of female mummies, such as the priestess Hathor, shower tattoos that may have been used as treatment for pelvic peritonitis.

Ancient Greece And Rome

Tattoos in Ancient Greece and Rome were again used as a punishment, as criminals were branded with marks to make them stand out from society.

Slaves were also branded to show ownership during this time. In some cases, they were often branded too to show they had paid their taxes.

Tattoos In The Dawn Of The 20th Century

As we move into the 20th century, we see that tattoos in many cultures are still very much considered taboo. At this time, the 'stick and poke' method was still the only way to get a tattoo, so they were very painful to get. If you had tattoos, you were often thought to an outsider.

Sailors and Tattoos

At this time, it was popular for sailors to get meaningful tattoos on their bodies. The images they chose all had significance. For example, a swallow showed the sailor had travelled 5,000 miles, while a turtle showed that they had crossed the equator. This is where nautical tattoos like anchors became popular, and are still highly requested tattoos even today.

It was also common for sailors in the navy, and army men too, to get patriotic tattoos. These were seen as a little more acceptable, but the idea of tattoos was still frowned upon

Circus Freaks

Tattoos were such an 'out there' concept in the early 20th century that people would actually pay to see them. Tattooed people would often travel with circuses, putting themselves on display. There were several tattooed people who became quite famous for the art they wore. One was John O'Reilly, who was billed as 'The Tattooed Irishman'. He has mentions in the Brooklyn Daily Eagle from as far back as 1887. They noted that his tattoos were a mark of his 'barbaric practices'.

Another famous tattooed performer was Emma de Burgh. She was tattooed by the same artist as John O'Reilly, and her tattoos were mostly religious in theme, referencing the Last Supper and the Calvary. She toured with her husband who was also tattooed.

1920's Cosmetic Tattoos

At this time, tattooing saw a boom in the female marketplace. It was seen as a good alternative to regular make up, as it was so expensive. Most commonly women would have eyebrow and lip liner tattoos done. However, at this point tattoos were still taboo, so many women would keep their tattoos a secret.

Social Security Number Tattoos

In the 1930's, Social Security Numbers were introduced, and the populace were sternly reminded that they must memorize their number. Some people were so concerned they would forget theirs that they took to tattooing the number somewhere on them, so they would always have access to it.

However, people who did this still kept it quiet. A theory at this time posited that getting a tattoo was a sexual act, so of course many kept this quiet.

World War 2 and Sailor Jerry Tattoos

As the world went to war, tattooing saw a real shift towards the mainstream. Men who went to war often got tattoos to commemorate their group, or got patriotic tattoos. Women back home also began to get tattoos to show their support towards the war effort.

At this time, the 'Sailor Jerry' tattoos became huge too. These simple designs often featured hula girls, patriotic designs, pins up girls, palm trees, and the classic 'mom' tattoo. These were created by Norman Keith Collins, and his designs still persist to this day.

Tattoos since The 1950's

As the war ended and life went back to normal, there was a serious shift towards the idea of a conservative, family life. Because of this, tattoos became underground again. Women were no longer getting tattoos as they did during The war, as this was again frowned upon.

The 60's and 70's

As we moved into the 60's and 70's though, there was another huge upheaval in society. People were beginning to question the status quo, and that lead to tattoos exploding in popularity. In the 60's, the peace sign became a popular tattoo as people battled against the Vietnam war, and patriotic designs declined popularity

In the 70's, tattoos were more main steam than ever before. Janis Joplin even was pictured for the cover of Rolling Stone magazine, sporting a tattoo on her left wrist. The art itself became more complex, featuring depth and shading. If you wanted a tattoo though, you were still having to pick a design from the parlour wall rather than being able to design your own.

Those who belonged to biker groups would often go for skull and skeleton designs, while hippies loved space designs. While they couldn't create their own tattoos, they had a lot of choice when it came to their tattoos

However, rumours went around during this time that tattoo parlours were to blame for a spread of Hepatitis. This wasn't true, but it did stigmatise the practice longer.

The Growth of the 80's

When the 1980's came around, tattoos were getting bigger and bolder, along with a lot of other fashions from the decade. One design that was very popular was the Celtic Knot, that came in all kinds of designs. Another popular art style was New School art, which was bright and bold, and often showed cartoon characters doing unexpected things.

The spread of tattoos was helped along by the music industry and especially MTV, which had it's debut in the 80's.

Feminine And Global Patterns
Of The 1990's

The proliferation of tattoos in the 90's only spread, and we saw a lot of newer designs come about. Feminine designs saw a real resurgence from WWII, and we saw butterflies, flowers, hearts, stars and more become popular. Celebrities influenced fashion with their designs, such as Mariah Cary with her delicate butterfly tattoo. Pamela Anderson sported her famous barbed wire upper arm tattoo, something that was copied globally.

At this point, tattoos were used as a form of healing, too. Women used tattooing after mastectomies to help themselves feel confident about their bodies, and often reclaim them after going through such an invasive procedure.

Tribal patterns became a big hit too, with people getting tribal designs, Chinese lettering, and so on. Later on, questions were asked about the ethics of having the designs of a culture other than your own tattooed onto your skin.

The new millenium and becoming Mainstream

It's clear that tattoos finally had their breakthrough into the mainstream in the 2000's. This was partly thanks to the rise of reality TV, and TV crews following people into tattoo parlours to see them get tattoos done. Viewers saw how personal tattoos were, and they became much more popular as a result. These shows even made celebrities out of tattooers like Kat Von D.

At this point, the lower back tattoo was a popular placement, and gained the unkind nickname of the 'tramp stamp'. These were often tribal designs, flowers, butterflies, and so on.

The finger tattoo became popular at this time too. Many people opted for moustache tattoos at the time when these were having a moment in pop culture.

Another popular tattoo was the semi colon, one that held a lot of significance for those who got it. The semi colon was a sign that a story wasn't over, something that those who struggled with mental health issues and suicidal thoughts took comfort in.

At this point, the idea of the 'seedy' tattoo shop finally died off. There were huge advances in sanitation, and we saw that tattoos were perfectly safe to get. As such, the number of people getting tattooed rose dramatically.

The Trends Of The 2010's
In the last decade

In the last decade, we saw all kinds of trends in tattooing. More and more people got tattooed, as workplaces relaxed their policies on visible tattoos. Tattoos were no longer seen as a taboo practice, and it was clear that those who were tattooed were as professional and regular as anyone else.

The art saw lots of different styles evolve, too. The watercolour tattoo brought new depths of colour to tattoos, creating beautiful delicate designs to many peoples' skin. There was also the biomechanical trend, where tattoos showed cogs and gears 'underneath' the wearer's skin.

The Future Of Tattooing

Where will tattoos go from here? It's hard to say, as it's so often difficult to spot trends in art. It's clear that tattoos have finally taken their place in the mainstream. More and more people get tattoos who would never have thought about them before. That means that we could see all kinds of art styles grow in popularity in the next decade.

Tattoos have been a feature of human expression for literally thousands of years. From the medical tattoos of Ancient Egypt to the watercolour tattoos all your friends are all getting, there's a lot of history. It's enough to make you find tattoo artist yourself. Maybe you'll be the one to kick start the next big trend?